This book
belongs to:

MARGARET SHEPHERD'S

Calligraphy

Projects

for Pleasure and Profit

OTHER BOOKS
BY MARGARET SHEPHERD

MARGARET SHEPHERD'S

Calligraphy

Projects

for Pleasure and Profit

A PERIGEE BOOK

Perigee Books
are published by
The Putnam Publishing Group
200 Madison Ave.
New York, N.Y. 10016

Library of Congress Cataloging in Publication Data

Shepherd, Margaret.
Margaret Shepherd's calligraphy projects for pleasure
and profit.

"A Perigee book."
1. Calligraphy—Technique. I. Title. II. Title: Calligraphy
projects for pleasure and profit.
NK3600.S538 1983 745.6'1 83-9579
ISBN 0-399-50908-9

First Perigee printing, 1983
Printed in the United States of America
6 7 8 9

TABLE of CONTENTS

INTRODUCTION

CALLIGRAPHY PROJECTS is designed for the beginning or intermediate calligrapher who needs practical advice. This book contains two dozen lettering projects, numerous 'how-to' illustrations, and over a hundred examples of finished designs as an idea source—plus 800 monograms for every combination of initials. In addition, the materials required are inexpensive & readily available locally in American towns.

Beautiful designs and ingenious production, however, are not all that this book has to offer. Each chapter is full of short, useful business tips—50 in all—and includes one long section analyzing in depth answers to some common problems the freelance calligrapher will encounter. Whether you want to expand your lettering into a business or simply bring your hobby up to professional quality, you'll benefit from the author's years of experience freelancing, teaching, and conducting calligraphy workshops.

CALLIGRAPHY PROJECTS charts the pitfalls, milestones, shortcuts, and goals. From its opening bookplate to its final colophon and traditional scribe's malediction, it will guide your pen by enlightening your eye.

Calligraphy
Projects

Calligraphy
Materials

CALLIGRAPHY MATERIALS

Finding the right materials for your calligraphy projects can be a valuable learning experience or a discouraging bafflement. It all depends upon your willingness to experiment, investigate, and evaluate. Be curious!

The materials listed here will vary widely in availability. Many approximate substitutes are suggested. Don't get hung up on one missing ingredient; try something else. Some commercial processes, but not all, may be an improvement over home-grown ones. The absolutely essential items are starred (*). And although a few specialized mail-order sources are listed, your first step should be to check local sources; supermarkets, hardware stores, dimestores, stationers, hobby shops, craft stores.

WRITING
Fine-line felt or fountain pen
* Small & medium calligraphy
 felt or fountain pens
Above pens in various colors
* #2 pencil

CUTTING
Scissors
* Single-edged razor blade
X-acto® knife
Sharp pocket knife
Paper cutter

PAPER

Stiff

Corrugated cardboard

Chipboard

Fom-Kor®

Shirt cardboard

Semi-stiff

Manila file folder

3" x 5" file cards

4" x 6" file cards, unlined

Floppy

Typing paper, not 'erasable'

Blue-lined paper in pads

Copy bond for practice

Specialty & parchment paper

WRAPPING

Saran® Wrap

Clear acetate

Shrink wrap

Krylon® spray

Calligra-Cote® spray

ATTACHING

Glue

★ Rubber Cement® or other naphtha-based glue

Diluted household glue

Diluted library paste

Self-gummed material

Sheets of labels for copiers

Individual name tags or labels

Transparent Contact® paper

Transparent gummed tape

Binding

Stapler

Needle & heavy thread

ERASING

★ Large non-abrasive eraser

Small abrasive eraser

RULING

★ Metal-edged ruler, inch & mm

9" 60°/30° triangle

4

DUPLICATING PROCESSES
Carbon paper (non-erasable ink-based)
Transfer paper (erasable graphite-based)
Photostat
Photograph (color slide)
Photograph (color or black & white prints)
Ditto
Spirit duplicator
Plain paper (Xerographic) copy
Treated-paper copy
Photo-offset
Wood or linoleum block
Letterpress
Silkscreen
Stencil

MAIL-ORDER SOURCES
BOOKPLATES, Antioch Bookplates, Yellow Springs, Ohio 45387

MANUFACTURERS OF CALLIGRAPHY PENS
write for information about retail sources nearest you

Fountain Pens
PELIKAN, Pentalic, 132 West 22nd Street, New York, N.Y. 10011
PLATIGNUM, Pentalic, 132 West 22nd Street, New York, N.Y. 10011
OSMIROID, Hunt Mfg. Co., 1405 Locust St., Philadelphia, Pa. 19102
SHEAFFER, Sheaffer, Pittsfield, Mass.

Marker Pens

CHIZ'L, Cooper Color, 300 Mercury Road, Jacksonville, Fla. 32207
DESIGN, Eberhard Faber, Crestwood, Wilkes-Barre, Pa. 18703
MARVY, Uchida, 69 51st Avenue, Queens, N.Y. 11377
NIJI, Yasumoto Co., 24 California Street, San Francisco, Cal. 94111
PENTALIC, Pentalic, 132 West 22nd Street, New York, N.Y. 10011
SANFORD, Sanford Corp., Bellwood, Illinois 60104
SPEEDBALL, Hunt Mfg. Co., 1405 Locust St., Philadelphia, Pa. 19102

MAIL-ORDER SOURCES OF CALLIGRAPHY SUPPLIES
PENTALIC, 122 West 22nd Street, New York, N.Y. 10011
CALLIGRAFREE, Box 96, Brookville, Ohio 45309

Calligraphy
Projects

CHAPTER

1

Calligraphy in the Kitchen

CALLIGRAPHY in the KITCHEN

Sooner or later, every calligrapher ends up practicing at the kitchen table. It's frequently the flattest, warmest, cleanest, and most efficiently organized work surface in the house — and the easiest to wipe up when the ink spills. It's also no coincidence that the kitchen is the natural setting for useful calligraphy; writing originated thousands of years ago in the recordkeeping tallies essential to the purchase and transport of food from grower to user. Today, it still takes a lot of written words to accomplish all the planning, shopping, reminding, concocting, preserving, and washing up that fill a typical kitchen. You don't need much practice before your projects will look good enough to appeal to other people for their kitchens.

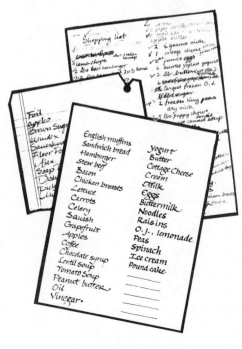

Let's start with something that you are likely to use oftenest, depend on most, and notice least — your grocery list. Save some typical scratchings on scraps and envelope backs, combine them into a master list, copy it neatly, and if possible have it machine photo-copied. Now you have the basis for a number of prefabricated lists.

THE COMPLETE SHOPPING LIST

BREAD/CEREAL	PRODUCE	DAIRY	STAPLES
Sandwich bread	Garlic	Milk	Flour
Brown bread	Onions	Buttermilk	Sugar
Raisin bread	Potatoes, red	Chocolate milk	Rice
English muffins	Potatoes for baking	Cream	Beans, lentils
Croissants	Carrots	Cottage cheese	Pasta
Raisin Bran	Celery hearts	Butter, salted	Spaghetti sauce
Most	Parsley	Butter, unsalted	Oil
Small cereal packs	Scallions	Cream cheese	Vinegar
Oatmeal	Spinach	Margarine	Salad dressing
Crackers	Mushrooms	Yogurt	Mayonnaise
Cookies	Broccoli	Cheese, sharp	Catsup
Bagels	Cauliflower	Cheese, mild	Mustard
Wheat Germ	Green beans	Tofu	Salt, soda, baking powder
	Avocado		Coffee
	Tomato		Herbal tea
MEAT	Cucumber	FROZEN	sugar cubes
Chicken breast boned	Eggplant	Juice concentrate	Peanut butter
Chicken thigh	Peppers	Ice cream	Jelly
Turkey	Sprouts	Vegetables	Marshmallows
Beef stew	Artichokes	Cake	Chocolate chips, m&m
Hamburger			Nuts
Liver			Dry milk
Lamb	Oranges	SUPPLIES	Baked beans
Steak	Grapefruit	Toilet paper	Honey
Pork	Bananas	Napkins	Syrup: choc., karo.
Soup bones	Grapes	Paper towels	Raisins
	Strawberries	Laundry detergent	Tuna
	Lemons	Dishwasher "	Herbs, spices
Hot dogs	Limes	Light bulbs	Worcestershire sauce
Bacon	Pears	Floor wax	Small fruit juice, V-8
Sausage	Pineapples	Shampoo	Tonic
Pepperoni	Cherries, berries	Toothpaste	Olives; black, green
Fish	Apples	Tissues	Soups

THURSDAY
Groceries
Wine
Placecards
Flowers
Cake

FRIDAY
A.M. vacuum
 Chill wine
4:45 Preheat oven
5:00 Lasagna in
5:15 Feed Chris
6:15 Light fire
 Start tape
6:30 Bread in
6:45 Broccoli on
 Toss salad
7:00 Serve

To be useful, a list must be specific. As far as you can, tailor your list to a particular store, person, group, time of year, or situation. Once you have completed any checklist, always ask yourself who else could make use of the same organized information.

[$] A list geared to shelf-order is a time saver if you always shop in the same store; an alphabetical list can transfer anywhere, to any person. Weigh the alternatives.

Ride Schedule

M	Mimi	PIANO	4:45
T	Joan	EXC.	3~5
	Carl	GYM	7~9
W	Mimi	BALLET	3:30
T	Carl	GYM	7~9
F			
S	Mimi	BALLET	3:30

REMEMBER!

- Bottle
- Cookie
- Tissue
- Diaper
- Pacifier
- Teddy

Garden Year

JANUARY
Force bulbs
FEBRUARY
Start seedlings
MARCH
Plant peas
APRIL
Feed lawn
MAY
Plant corn, beans
JUNE
Transplant tomatoes
JULY
Pull up weeds
AUGUST
Harvest corn
SEPTEMBER
Make compost
OCTOBER
Take houseplants in
NOVEMBER
Rake, plant bulbs
DECEMBER
Clean potting shed

ENERGY CHECKLIST

- Shades closed?
- Thermostat lowered?
- Fireplace flue closed?
- Lights off?
- Space heater off?
- Living room door closed?
- Stereo off?

If you offer a checklist with some extra space or blank guidelines, people who use it can tailor it to their individual needs.

A beautiful list never stops advertising for you. Always include on it your name or business name, and number.

Flowers and Greetings by Greta
Meadow Road, Baro. Ca. 92121

CAMPING CHECKLIST

Bread	Canteen	Bandages
Dry milk	Backpack	Moleskin
Peanut butter	Map	Sunblock
Nuts	Compass	Bug repellant
Raisins	Altimeter	Tissue
Chocolate	Gloves	Army knife
Apples	Binoculars	Matches
Bottle opener	Dry socks	Aspirin

Mom—we'll bring:

TURKEY	PLUM PUD
Stuffing	Calvados
Baster	Hard sauce
Carving set	Raisin sauce
Gravy boat	Holly
Whisk	Mistletoe

the
BEER
is
still
in
THE
FRIDGE

Have a nice

trip!

12

Lists can nudge your memory about not only what to buy for your kitchen but also what to use it for once you get it home. A simple checklist of your spice cabinet supplies can, with a little cultivation, blossom into a chart for well-seasoned cooking. Note what goes well in what kinds of recipes.

A spice list can be a group project. Pass your rough draft around to collect suggestions for using spices. Incorporate into a finished list, letter, machine copy, distribute to participants.

Basil	Cucumber salads, tomatoes, cottage cheese
Bay Leaves	Stew, soup, baked beans, chowder
Cinnamon	Applesauce, toast, hot cider, fruit compote
Cloves	Ham, hot cider, cooked fruit
Curry	Devilled egg, stew, dip, sauce
Garlic	Stew, hamburgers, bread, sauces, roast beef
Mint	Lamb, iced tea, ice cream, fruit cocktail, peas
Nutmeg	Egg nog, custard, coffee cake, chocolate milk
Onion Salt	Hamburgers, stew, stock, meat loaf
Oregano	Spaghetti sauce, salad dressing, marinade
Paprika	Fish, cheese sauce, cauliflower
Parsley	Omelets, meat loaf, casseroles, spaghetti sauce
Pepper	Eggs, meat, salads, marinade, spaghetti
Rosemary	Lamb, chicken, barbecue sauce, fruit punch
Sage	Turkey, chicken, pork, sausage, chowder
Tarragon	Fish, chicken, eggs, béarnaise, mayonnaise

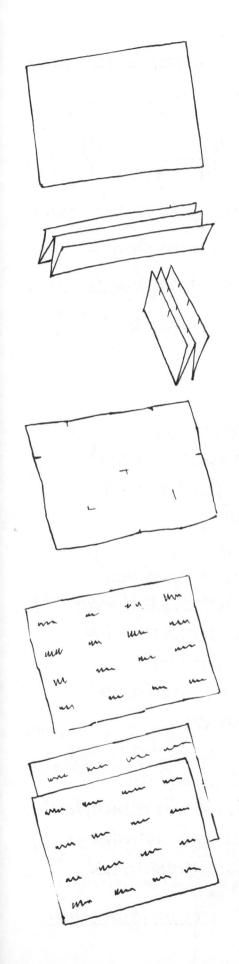

Your spice chart can be as decorative as your time and patience can make it. A little research will turn up pictures of spice and herb plants to decorate the names. From a utilitarian list on blue-lined paper you can progress to a more complicated layout involving a separate square for each spice and herb. Start with three sheets of the same paper: the first for rough draft, the second for finished calligraphy, the third for when you make an error on the second. Fold the paper in four each way to make 16 squares, flatten it back out, and pencil the spice name lightly in the middle of each square. Rule a pencilled guideline, leaving room for any planned ornament and explanation. (Sketching the word first, before you draw guidelines, gives you more freedom in placing the name and determining what size to make it.) Letter in ink carefully, not crowding words to fit; adjust centering after first draft.

Other possibilities; Anise, Dill, Marjoram, Mustard, and Thyme.

Basil Bayleaves Cinnamon Cloves

Curry Garlic Mint Nutmeg

OnionSalt Oregano Paprika Parsley

Pepper Rosemary Sage Tarragon

A spice chart makes a nice housewarming or shower gift. It can be sold readily as such if packaged with a cookbook, spices, herb seeds, or herb plants.

If you give away or sell a finished piece of calli-graphy, ALWAYS keep a machine copy, photograph, tracing, or at the very least your next-to-last draft.

No need to be paranoid, but in addition to signing a well-done piece of calli-graphy, write 'copyright ©', your name, & the year. It is a simple precaution.

Your wall chart for herbs and spices can easily transform itself into a set of useful, pretty, and original labels. First spread a thin layer of rubber cement on the back of the paper. Let it dry completely. Then spread a thin layer of rubber cement on the area of each bottle where a label is to go. Let that dry. Cut, tear, or scissor the sheet into individual labels along the existing crease lines & attatch to bottles. Gently rub off excess rubber cement.

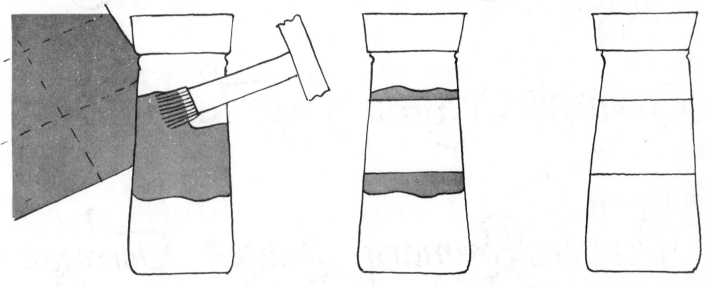

[$] Before you cut up your carefully lettered sheet into labels, run a copy or make a tracing or use your draft and do a rehearsal of the gluing, drying, & bonding procedure. Don't experiment with your best copy

[$] If you want to fool-proof the application of the labels for others, buy sheets of pressure-sensitive labels and letter the spice names directly onto them. Some brightly colored labels are available.

[$] If you have access to a copy machine, try putting specially formulated* sheets of labels into the machine's paper tray & copying a handlettered original right onto them.

* Must be specifically for copiers.

Some decorative spice labels are shown here as starting points.

Cinnamon	CINNAMON	Cinnamon
Cloves	CLOVES	Cloves
Curry	CURRY	Curry
Garlic	GARLIC	Garlic
Nutmeg	NUTMEG	Nutmeg
Onion Salt	ONION SALT	Onion Salt
Paprika	PAPRIKA	Paprika
Pepper	PEPPER	Pepper

Labels lettered in this 3 × 10 format can be photocopied onto special 8½" × 11" sheets of labels.

Some decorative herb labels are shown here as starting points.

Basil

BASIL

Basil

Bay Leaves

BAY LEAVES

Bay Leaves

Mint

MINT

Mint

Oregano

OREGANO

Oregano

Parsley

PARSLEY

Parsley

Rosemary

ROSEMARY

Rosemary

Sage

SAGE

Sage

Tarragon

THYME

Tarragon

Labels lettered in this 3 × 10 format can be photocopied onto special 8½" × 11" sheets of labels.

❧ If you are selling your labels not only as a money-maker but also to generate publicity, use labels large enough to include your business or group name in small lettering across the bottom or in a corner. Accustom yourself to signing all your work in some form.

When you are designing labels always try to visualize how and where they will be used. Try one out on the lid of a typical spice bottle BEFORE you letter 50 of them just one eighth of an inch too wide: rub a damp thumb over a trial letter BEFORE every label smudges under normal use: check the color scheme of a friend's new kitchen BEFORE you lovingly letter something that just doesn't match.

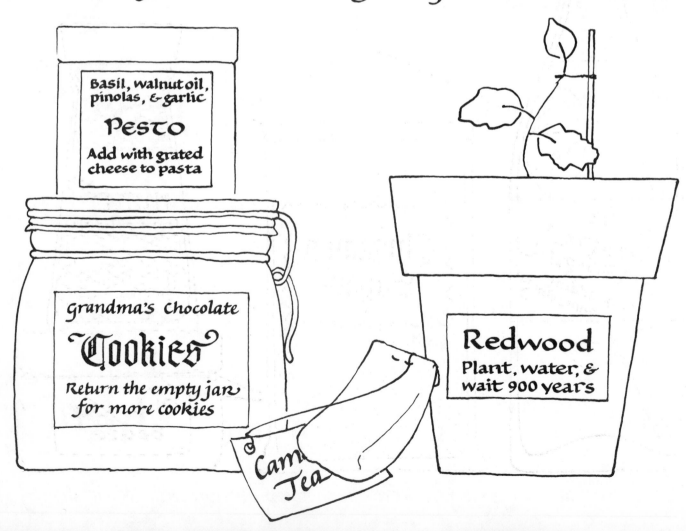

Basil, walnut oil, pinolas, & garlic
PESTO
Add with grated cheese to pasta

grandma's chocolate
Cookies
Return the empty jar for more cookies

Redwood
Plant, water, & wait 900 years

Cam
Tea

☒ *Check application instructions on label box. Whenever you can, add this information to any labels you sell or give, along with suggestions of your own for application, use, and removal.*

Labelling doesn't have to stop at the spice shelf. Label your handmade jams, jellies, cookies, candy, wine, pickles, preserves, plant cuttings, & potpourri. Labels are versatile. You can give information, suggest uses, tell a background story, add appeal, describe special ingredients, create a decorative miniature, invent a product complete with package design, and even help recycle the empties!

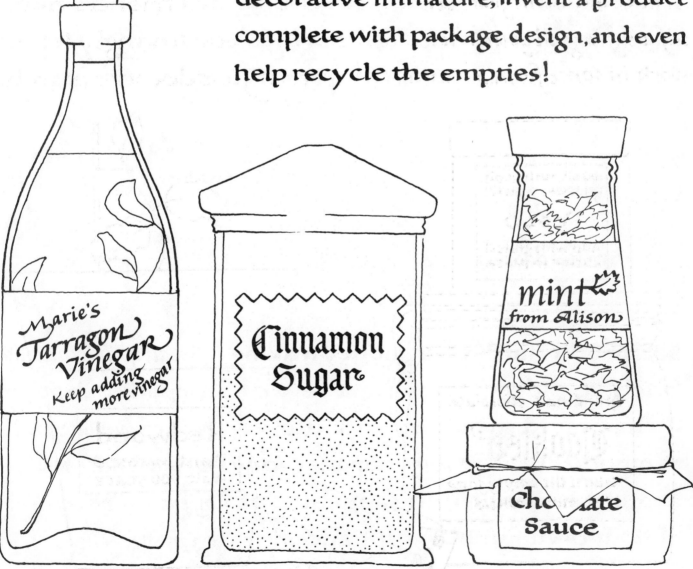

Marie's Tarragon Vinegar
Keep adding more vinegar

Cinnamon Sugar

mint
from Alison

Chocolate Sauce

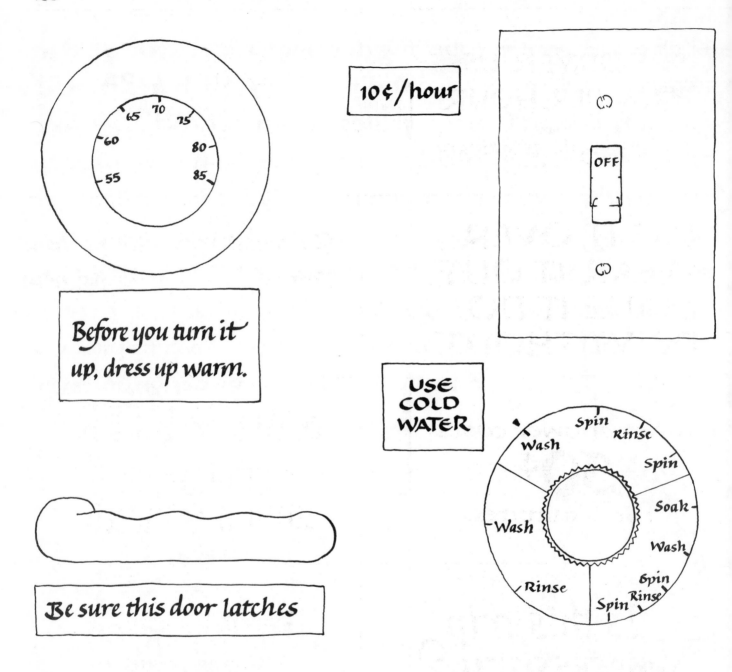

10¢/hour

Before you turn it up, dress up warm.

USE COLD WATER

Be sure this door latches

Before you finish your money-making labels, consider employing a few of them around the house and kitchen as money savers to jog your memory about the energy-using appetites of of your own familiar appliances.

$ Call your local utility companies or check the back of your latest bill for exact rates. Multiply by each appliance's usage rating.

THE DRYER USES
40¢ PER HOUR

Hang up heavy things to air dry

LOOSE LIPS
ADD HIPS

USE IT OVER,
WEAR IT OUT,
MAKE IT DO,
DO WITHOUT.

Air conditioner 10¢ per hour
Fan 2¢ per hour

A hot shower costs
50¢
for 5 minutes

SAVE WATER
Shower
with a Friend

*Is this trip
necessary ?*

The light costs
$10 per month
so turn it off !

ONE DOUGHNUT
equals five miles
or one inch.

Eating
again?

Labels lettered in this 2 × 5 format can be photocopied onto special 8½" × 11" sheets of labels.

From a comprehensive wall chart of spices and herbs with recommendations for how to use them, it is only a very short jump to individual recipes lettered for framing, filing or collecting. They make good practice for the beginning calligrapher, attractive sale items and promotional projects for an organization, and welcome gifts for showers and housewarmings.

[$] Strike a balance between the various uses a decorative recipe has. It should be a useful recipe, calling for enough different ingredients, operations, and measurements to justify not relying on memory, and yet not be so complicated & exotic that it will be seldom in demand. And while it should be long enough to be interesting, it must be short enough to allow a little space for decoration.

HOW TO BOIL WATER

Put water in saucepan
Heat until boiling

do not watch

TURTLE SOUP

INGREDIENTS.— A turtle, 6 slices of ham, 2 knuckles of veal, 1 large bunch of herbs, 3 bay leaves, parsley, green onions, 1 onion, 6 cloves, 4 blades of mace, ¼ lb of fresh butter, 1 bottle of Madeira, 1 lump of sugar.

MODE.— To make this soup with less difficulty, cut off the head of the turtle the preceding day. In the morning open the turtle by leaning heavily with a knife on the shell of the animal's back, whilst you cut this off all round. Turn it upright on its end, that all the water, &c may run out, when the flesh should be cut off along the spine, with the knife sloping towards the bones, for fear of touching the gall, which sometimes might escape the eye. When all the flesh about the members is obtained, wash these clean and let them drain. Have ready, on the fire, a large vessel full of boiling water, into which put the shells; and, when you perceive that they come easily off, take them out of the water, and prick them all, with those of the back, belly, fins, head, &c. Boil the back and belly till the bones can be taken off, without, however, allow-

ing the softer parts to be sufficiently done, as they will be boiled again in the soup. When these latter come off easily, lay on earthen dishes singly, for fear they should stick together, and let them cool. Keep the liquor in which you have blanched these softer parts, and let the bones stew thoroughly in it, as the liquor must be used to moisten all the sauces.

All the flesh of the interior parts, the four legs and head, must be drawn down in the following manner:—Lay the slices of ham on the bottom of a very large stewpan, over them the knuckles of veal, according to the size of the turtle, then the inside flesh of the turtle, & over the whole the members. Now moisten with the water in which you are boiling the shell, and draw it down thoroughly. It may now be ascertained if it be done by thrusting a knife into the fleshy part of the meat. If no blood appears, it is time to moisten it again with the liquor in which the bones, &c have been boiling. Put a bunch of sweet herb in — sweet basil, lemon thyme, sweet marjorum, winter savory, 2 or 3 bay leaves, common thyme, a handful or so of

parsley and green onions, and a large onion stuck with 6 cloves. Let the whole be very thoroughly done. With respect to the members, probe them, to see whether they are done, and if so, drain and send them to the larder, as they are to make their appearance only when the soup is completely done. When the flesh is also completely done, strain it through a silk sieve, and make a very thin white roux; for turtle soup must not be much thickened. When the flour is sufficiently done on a slow fire, and has a good colour, moisten it with the liquor, keeping it over the fire until it boils. Ascertain that the sauce is neither too thick nor too thin; then draw the stewpan on to the side of the stove, to skim off all the white scum, and all the fat and oil that rise to the surface of the sauce. By this time all the softer parts will be sufficiently cold; when they must to the size of one or two inches square, and thrown into the soup, which must now be left to simmer gently. When done, skim off all the fat and froth. Take all the leaves of all the herbs from the stock,—sweet basil, sweet marjorum, lemon thyme, winter savory, (OVER.)

From THE BOOK OF HOUSEHOLD MANAGEMENT by ISABELLA BEETON 1861

First try lettering one of your most often used recipes on an 8¼"x 11" sheet of paper. Some designs are suggested here for a start.

💲 To make a fundraiser recipe collection, give a uniquely personal gift, or just organize your own kitchen, bind your recipe sheets into a cook book. Punch a hole in one corner and tie together; three-hole punch and ring bind; ask a printer to "GBC" or claw bind your recipes.

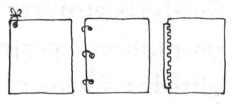

Ratatouille
à la Grecque

INGREDIENTS

¼ lb. bacon, chopped
1 eggplant, cubed
1 onion, sliced
1 garlic clove
3 tomatoes, peeled, seeded, cubed
2 celery stalks, sliced
2 T Butter
½ t Salt
¼ t pepper
2 T parsley

Breadcrumbs
Grated parmesan

INSTRUCTIONS

Fry bacon until crisp. Pour off fat. Add butter and heat until melted. Add onion, garlic, and celery; sauté 5 minutes. Add tomatoes, eggplant, and seasonings, transfer to casserole, top with crumbs and cheese, and bake at 350° for 2 hours.

Good hot or cold

Ratatouille

Chop ¼ lb BACON. Fry until crisp. Drain. Add 2 T BUTTER. Heat until melted. and 1 chopped ONION. and 1 clove GARLIC, and 2 stalks sliced CELERY. Sauté 5 minutes. Add 3 seeded & cubed TOMATOES, and 1 cubed EGGPLANT. and ½ T SALT. and ¼ t PEPPER, and 2 T PARSLEY. Pour into casserole. Top with BREADCRUMBS, and PARMESAN CHEESE.

Bake 2 hours at 350° Good hot or cold. Serves 6.

RATATOUILLE

Chop ¼ lb BACON. Fry until crisp. Pour off fat. Add 2 T BUTTER; heat until melted. Add 1 chopped ONION. 1 clove GARLIC, 2 stalks sliced CELERY; sauté 5 minutes. Add 3 peeled, seeded, & cubed TOMATOES, 1 cubed EGGPLANT, ½ t SALT, ¼ t PEPPER, 2 T PARSLEY, transfer to a buttered CASSEROLE dish, top with BREADCRUMBS and grated PARMESAN CHEESE. Bake for 2 hours at 350.° Good hot or cold. Serves 6.

Your recipe sheet should be backed and wrapped to protect it from tears, folds, and stains. To cut the backing pencil lightly around the outline of the sheet onto the backing material. Lay a metal or metal-edged wooden ruler next to the pencilled line; pad your work surface with at least 20 layers of newspaper. Pressing down solidly on the ruler, cut through the backing with a kitchen knife, utility knife, or single-edged razor, being extremely careful that your fingers do not get nicked by the blade. If you are all thumbs (and don't want to lose any of them), draw around your sheet with pencil and then cut with scissors or paper cutter. Now lay sheet and backing together and gently wrap with clear plastic kitchen wrap, overlapping 2". Fasten with tape onto the stiff backing. Make a hanger as shown here from a 4" piece of tape & a 1" square of backing material.

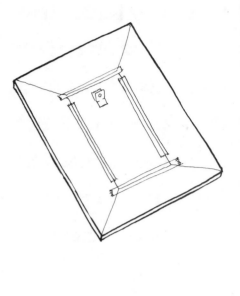

It is better to offer your work for sale mounted as simply as possible, to let the buyers decide for themselves how they want it framed. Use posterboard, foam-core, or oak tag for backing. If you use corrugated cardboard, tape the edges with opaque tape to remove some of the 'low-budget' look.

POTPOURRI

all ingredients must be dried before mixing

8 cups pink rose petals
2 cups lavender flowers
1 cup shredded orange peel
1 cup crushed cloves
⅛ cup powdered nutmeg
1 cup marigold petals
1 cup mint leaves
¼ cup orris root powder

Gesso for Gilding

measure with salt spoon

18 slaked lime
6 white lead
1 sugar
1 honey
2 glue
1 Armenian bole
9 distilled water

grind in mortar & pestle. Dry 5 days.

One unexpected side-benefit of putting your kitchen procedures and recipes down on paper is that it makes it easier for other people to help out. Hand lettered work assignments & schedules can make your lives run more efficiently. (Save a few for your family's scrapbook or archives.)

For extra appeal to your public as well as more of a challenge to your design skills, try a basic recipe with some variations included in the layout. Soup, stew, bread, omelets, pâté, and even the humble hamburger lend themselves to a treatment whose form and content both suggest a theme and variations.

Recipes don't have to be for things that you eat for supper. You can find many fascinating and useful recipes for making medicine, soap, drinks, perfume, cosmetics, dye, alcohol—and of course for all of the ingredients of traditional calligraphy, papermaking, gilding, binding & illuminating

▣ If your recipe needs more space, use two file cards hinged together— even in preference to one card front & back, which is a nuisance to flip back and forth while you cook.

▣ Slip your handlettered recipe cards into clear plastic sleeves, or spray with a waterproof spray to guard against the inevitable spills, stains, & smears of kitchen use.

You can scale down your sheets to fit file cards. 3" x 5" is a more common size, but 4" x 6" gives you more room. Either one offers you the challenge of fitting a lot of material into limited space. Keep ornament to a minimum; use color rather than extra details for decorative effect. If you letter the ingredients and amounts in a contrasting color you can both decorate and clarify your recipe at the same time.

CRÊPE BATTER

1 cup flour
½ T salt
1½ cup milk
2 eggs
3 T butter (melted)

Mix together in blender or beat in bowl. Chill 1 hour; will keep in refrigerator 4 days.

Pour thin layer into hot oiled skillet. Turn over when edges are brown & lacy.

CRÊPE FILLINGS

Jelly & jam
Lemon & sugar
Turkey & gravy
(top with cranberry relish)

Creamed tuna
Spinach
Ice cream
Leftovers
Sour cream

CRÊPE BATTER

1 cup flour
½ T salt
1½ cup milk
2 eggs
3 T butter (melted)

Mix together in blender or beat in bowl. Chill 1 hour; will keep in refrigerator 4 days.

Pour thin layer into hot oiled skillet. Turn over when edges are brown & lacy.

CRÊPE FILLINGS

Jelly & jam
Lemon & sugar
Turkey & gravy
(top with cranberry relish)

Creamed tuna
Spinach
Ice cream
Leftovers
Sour cream

A FISH TO BE TENDER MUST SWIM THRICE IN WINE, IN WATER, IN BUTTER, AND

CLAY DOUGH

Cook in saucepan 4 minutes: 1 cup flour, ¼ cup salt, 2 T Tartar, 1 cup water, 1 T oil, 2 T Food coloring (op).

super Sangria

red wine	grenadine
orange juice	triple sec
orange slices	club soda
lemon slices	ice cubes

Combine in a tall pitcher & stir

BAKED BEANS

Soak flat beans overnight, boil one hour. Add 1 chopped onion, ½ cup molasses, ½ cup ketchup, salt, pepper, bay leaf, & piece of salt pork. Bake 2 hours 350°.

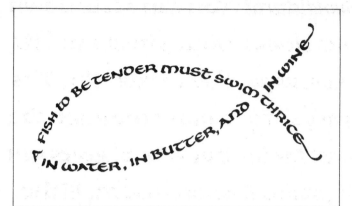

ore six apples

Fill centers with raisins, walnuts, brown sugar, wheat germ, cinnamon, cloves, and nutmeg. Bake one hour at 300°. Cool. Serve with cream.

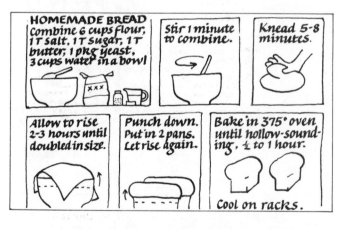

HOMEMADE BREAD

Combine 6 cups flour, 1 T salt, 1 T sugar, 1 T butter, 1 pkg yeast, 3 cups water in a bowl

Stir 1 minute to combine.

Knead 5-8 minutes.

Allow to rise 2-3 hours until doubled in size.

Punch down. Put in 2 pans. Let rise again.

Bake in 375° oven until hollow-sounding, ½ to 1 hour.

Cool on racks.

From the kitchen of *Jean Wu*

MUFFIN PIZZAS

Mozzarella cheese
Pepperoni
Tomato sauce
Butter
Toasted English muffin

COOK 2 MINUTES UNDER VERY HOT GRILL

Now you have the basis for perhaps the most popular kitchen calligraphy project of all: the short quotation that has special meaning for the person who uses the kitchen most. Such quotations are not necessarily about cooking and eating; rather, they echo that peaceful, busy, and fundamentally humane state of mind that is nourished by this kind of work.

brillat-savarin

Tell me
what you eat
and I will
tell you
what you are

Kitchen quotations are best done on file cards or quarter-sheets of paper, since they are usually brief & will be seen from close up. They are also easier to back, wrap, and hang up in the limited wall space of the typical kitchen.

If only I may grow

FIRMER,
SIMPLER,
QUIETER,
WARMER.

Dag Hammarskjöld

IT IS
sheer foolhardiness
TO BE
ARROGANT
TO A
Agnes COOK Repplier

THE
WAY
ONE
EATS
IS THE
WAY
ONE
WORKS

CZECH PROVERB

Eating maketh a full man,

Confections a heavy man,

Imbibing an inexact man.

after Francis Bacon

All cooking is a
matter of time;

In general,
the more time, the better.

John Erskine

Grub first then ethics

bertolt brecht

To storm a breach, conduct an embassy, govern a people, these are brilliant actions; to scold, laugh, and deal gently and justly with one's family and oneself, that is something rarer, more difficult, and less noticed in the world.

MONTAIGNE

Kitchen quotes make good crafts-fair items. You can make use of the time you spend at the fair by lettering short quotes to order for a small fee.

Do all the good you can,
By all the means you can,
In all the ways you can,
In all the places you can,
At all the times you can,
To all the people you can,
As long as ever you can.

John Wesley's rule

IT'S THE WINE TALKING

Blessed are they who clean up.

Whether you enjoy doing calligraphy as an amateur or aspire to become a professional, you should give some thought to your portfolio. Give your lettering (and yourself) the respect it deserves by presenting it in an attractive way.

First, always do the very BEST JOB you can, so that your work speaks well for you whether it is in your portfolio or on display elsewhere. Otherwise the one job you scrimp on is the one job that gets seen by the one person whom you were wanting to impress.

Second, keep COPIES of every job you do — photographs, photostats, printed reproductions, machine copies, rough drafts, or even tracings. They help give the customer an idea not only of the quality of your work but also of the variety of your practical experience.

Third, SELECT only your best work for inclusion in your portfolio. It is better to have too few things for a while than to have a lot of things that don't represent your real capabilities.

Fourth, ARRANGE your work in logical groupings so that you can zero in on your customer's area of interest. And if, for example, your collection of addressed envelopes seems a little meager, invent a few more examples to fill gaps in your collection.

Fifth, UPDATE your portfolio periodically. Weed out weaker items and insert new ones as your calligraphy improves.

Sixth, PACKAGE your work in an attractive album, binder, or portfolio. Remember that people may be judging not only your calligraphy but the attention to detail you show in displaying it.

<u>Seventh</u>, be POSITIVE. Let your work speak for itself. Add just a few verbal details if the portfolio is not self-explanatory, but don't apologize for any imagined shortcomings. If people have noticed anything to criticize, nothing you can say will make much difference. If they haven't noticed anything to criticize, you should by no means draw their attention to it. Leave well enough alone.

<u>Eighth</u>, BE BRIEF.

<u>Ninth</u>, leave a CARD or printed sample behind so that people who cannot use your work right away will remember where to find you when they need you.

<u>Tenth</u>, be PATIENT.

Calligraphy
Projects

CHAPTER
II

Calligraphy
for
Stationery

CALLIGRAPHY for STATIONERY

Writing — whether considered as literature or as art — originates from self-awareness and the desire to share that self with others. Almost from the dawn of civilization, people have put their signatures on things, from the outlined handprints on Paleolithic cave walls to Mesopotamian cylinders and medieval signet rings. Many people begin their study of calligraphy with the innocent intention of improving their own handwriting, only to find themselves absorbed into a wider, deeper, more rewarding tradition of artistic expression than they had expected. The impulse to write something, sign it, and send it to someone else has been the genesis of many a serious calligraphic career.

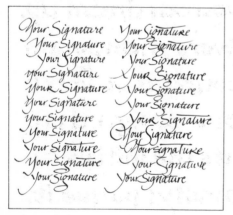

⚜ You can help design an organization's "signature" as well as a person's.

You can reshape a signature gradually, or go about it systematically with this signature-stretching exercise: Using a thick pad of blue-lined paper and a small-to-medium calligraphy pen, write your name AT LEAST one hundred times. Don't work too slowly or carefully; do keep your eye out for lucky calligraphic slips of the pen.

FL FL fl fl

fl FL FL FL

FL E FL FL

FML fml fml fml

fml FVL FVL FVL

FML FML fml fml

After exploring the calligraphic potential of your whole name, next try a few of the designs that can be made with your initials. As with signatures, try your own two or three letters, in quick succession, in as many related variations of style, size, position, and embellishment as you can dream up. Every monogram contains at least one design that fits the initials naturally; pursue it. 676 combinations are shown here as jumping-off points

§ If you design a three-initial monogram, ask if the person already has a preferred order for the First, Middle, and Last.

FML FML FLM
LFM LML FML

People often already think of just one order as right.

To use the following thirteen pages of monograms, provide yourself with a ⅛" calligraphy marker and several sheets of paper marked off into ¾" x 1" boxes. If you use a larger 3.5 mm pen, make the boxes 2cm x 3cm.

Remember that you are designing not a line of lettering but a single, self-contained unit that has the simple task of putting your initials into interesting juxtaposition.

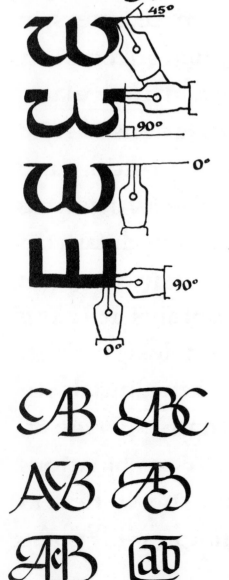

You don't have to use the only design that shows your initials together. Try other monograms that contain one or another of your initials. These designs all use the same pen, but some of them use a different pen angle from the natural writing position you may be used to. Study the ends of the strokes for clues to what pen angle to use. A few monograms require two different pen angles; change angles between strokes. Many of these monograms have space for a third initial. Add it before, behind, above, below, inside, or outside the existing two initials.

A AA AB A ad ae

af G AH A di AK

AL M N A P aq

AR s ct AU AV XX

X AZ B ba bb

bc bd BE bf bg bh

b B bk b bm bn

bo bp bq BR HS bt

bu bv bw bx by bz

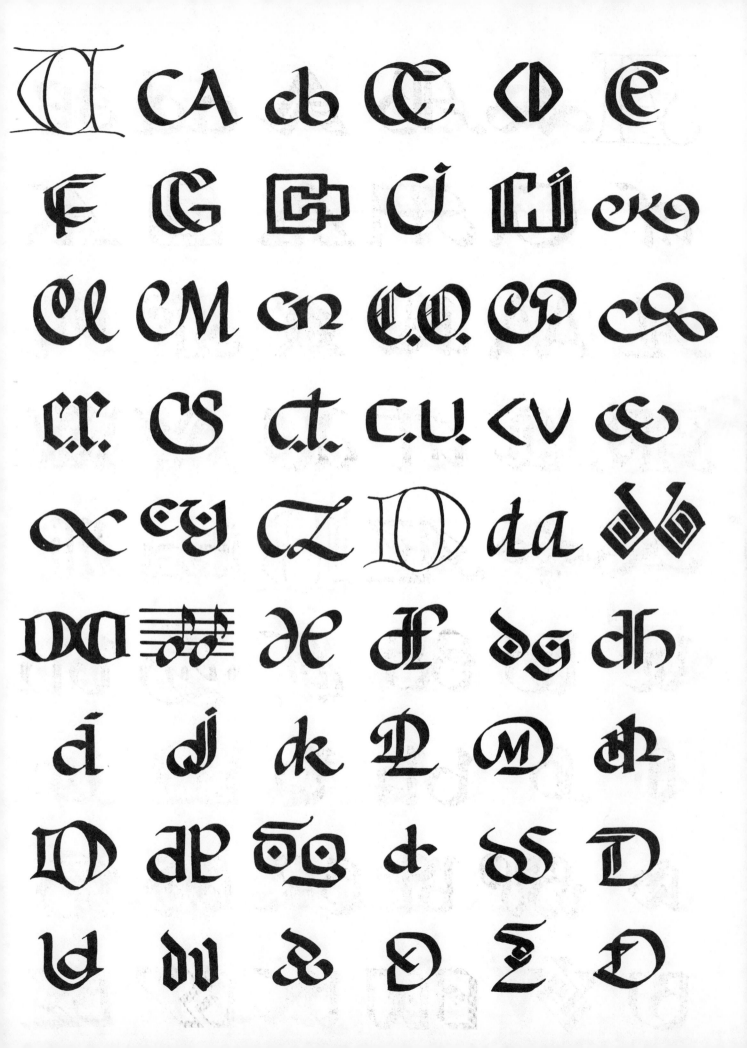

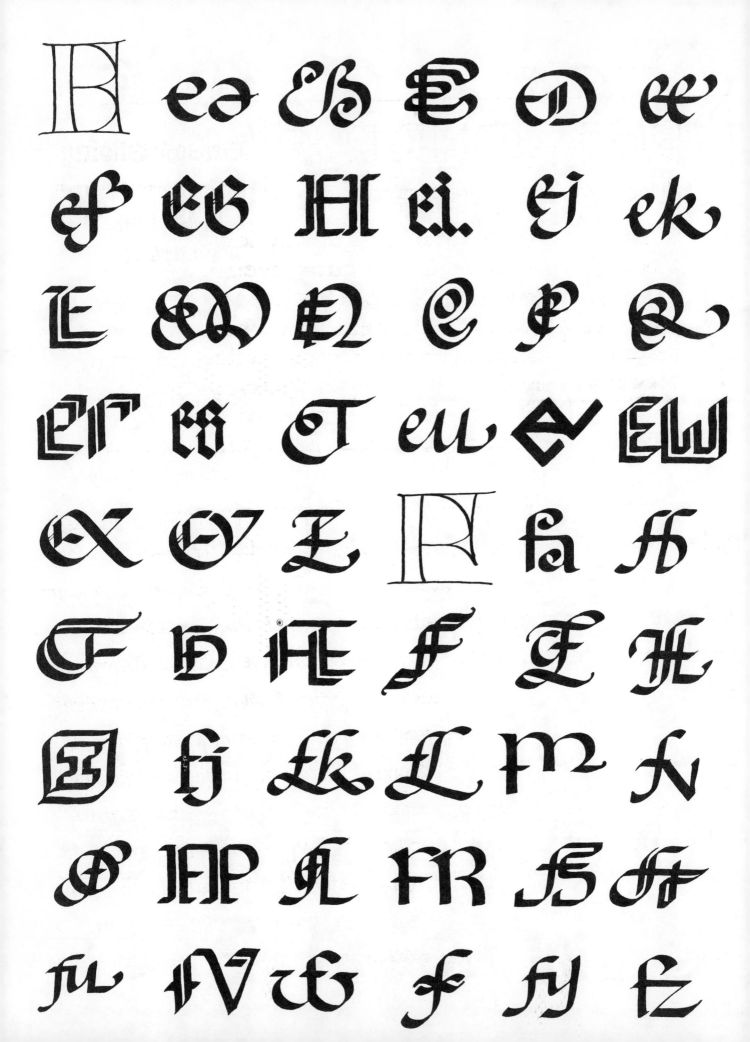

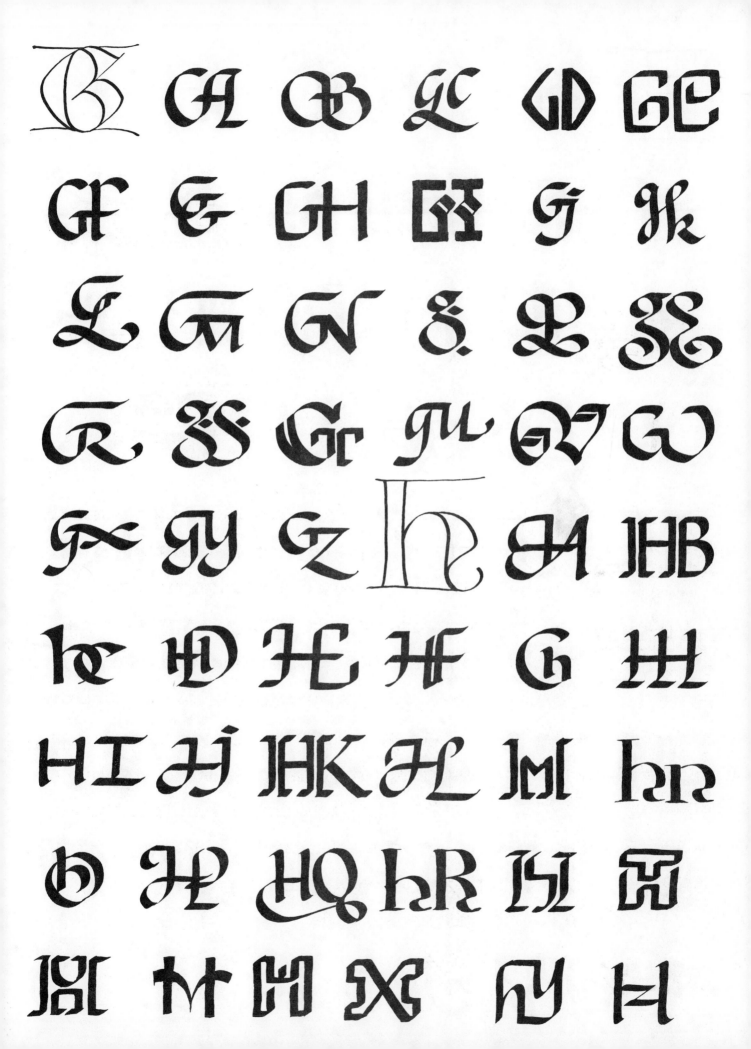

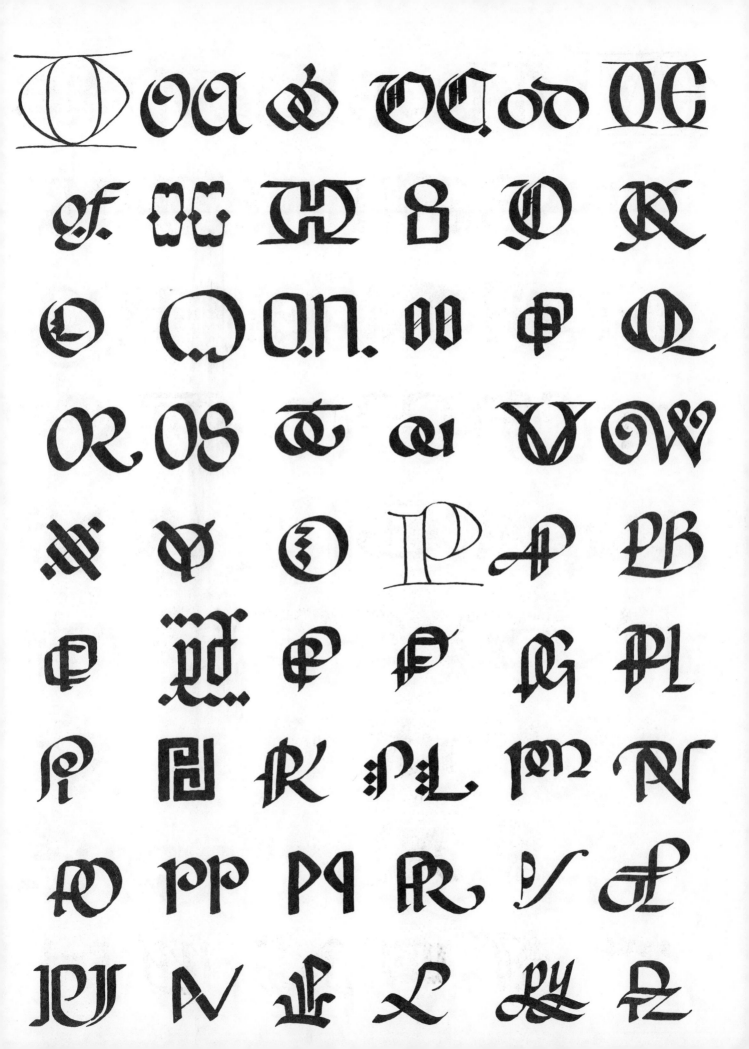

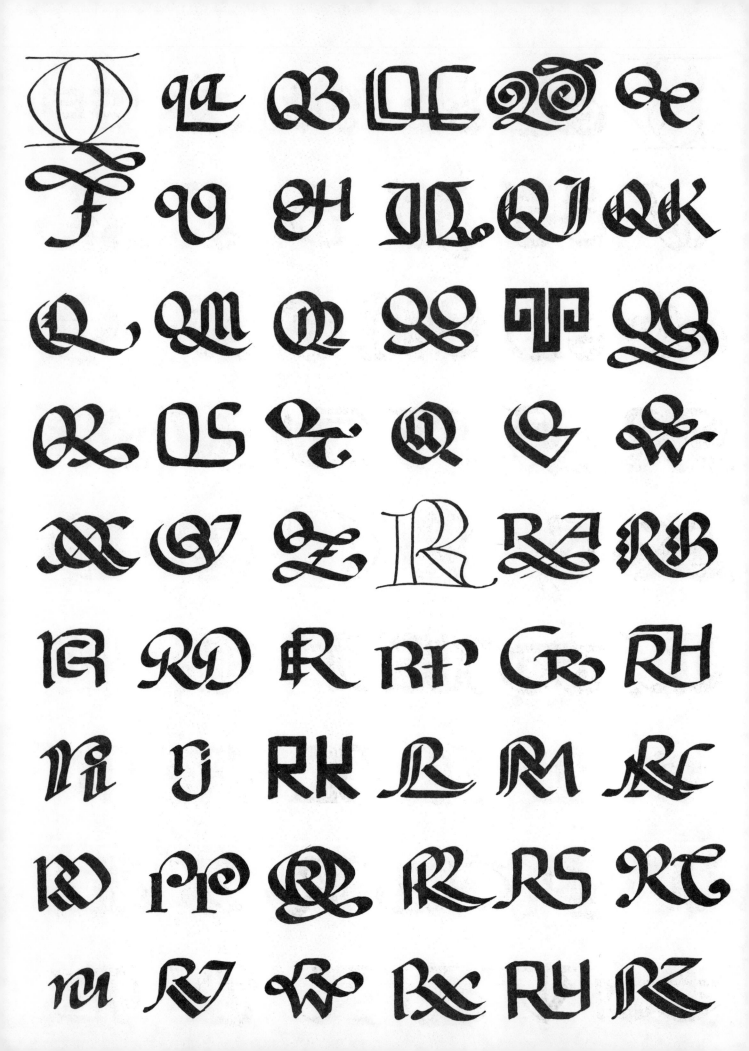

S A B C D SE

F SS H S I sk

L M N O P Q

R S T U N

X Y I T A B

T E F G th

ti H K L M N

W P Q R S T

W V X Y Z

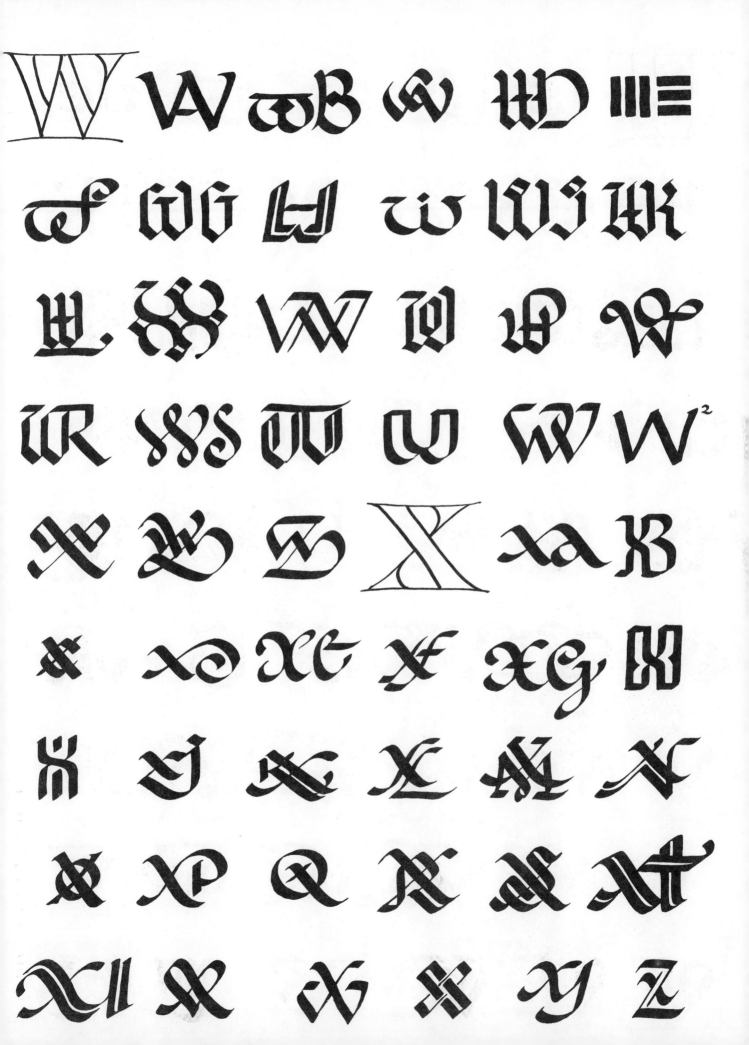

ABCDEFGHIJKLM
NOPQRSTUVWXYZ

abcdefghijklmnopqrstuvwxyz

ABCDEFGHI
JKLMNOPQR
STUVWXYZ

abcdefghijklmnopqrstuvwxyz

abcdefghijklmnopqrstuvwxyz

To make your mono-
gram into stationery,
letter it onto good-
quality writing pa-
per. Experiment a
little with different
placement, design,
style, size, ink color,
and paper color to
find a combination
that best expresses
your personality.
You can give an im-
pression of formal-
ity and reserve, of
strength and sim-
plicity, of humor &
playfulness, or of in-
formality & warmth.
Pay attention, also,
to other people's
stationery designs;
analyze what they
communicate & how.

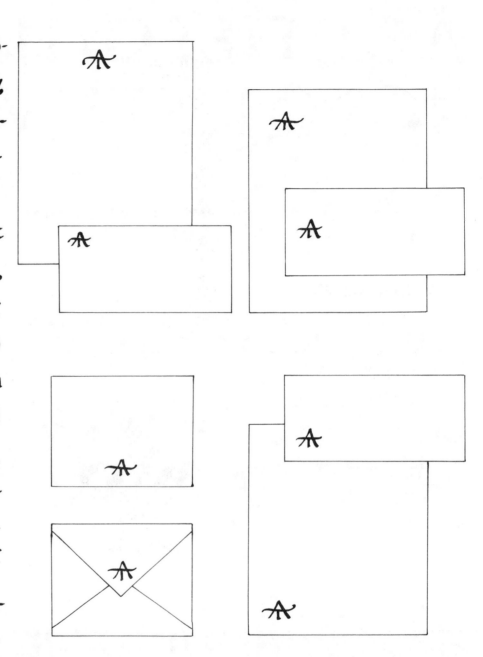

🖏 If you are designing
stationery for someone,
don't just show a mono-
gram by itself. Place it
in a few sample layouts
as shown here to see how
it might look in use.

🖏 Once you have chosen
a stationery design, give
it one last trial to see how
the design looks when
you write an everyday
message on it in your
own handwriting.

William Marsh

🔹 Don't limit yourself to using a monogram in just one size or by itself. Try it an order of magnitude smaller or larger, and experiment with the effect of repetition.

🔹 If you put a monogram low on the page, take a minute to make sure the ink will not smear or print onto the prospective user's writing hand (right or left).

🔹 A design for a joined pair of monograms is the perfect wedding gift. Give it early enough for use on thank-you-notes and other stationery.

To save labor and standardize your stationery, try a rubber stamp. It can be ordered by mail or through a stationery store, or you can handmake one yourself. First, practice cutting a simple block letter. Write or trace one on the end of an eraser. Using an "x-acto" knife, scalpel, very sharp kitchen knife, or single-edge razor, carve away the background to a depth of ¼ inch, so that only the letter remains. Remember to reverse the letter so it prints right!

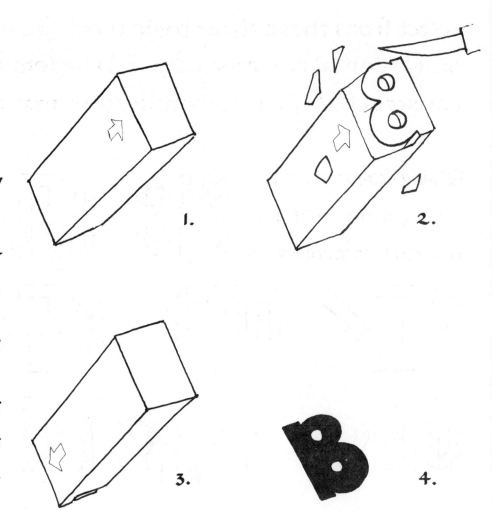

1.

2.

3.

4.

⟪$⟫ With some practice you can carve a simple initial stamp while people wait, or take orders for delivery while you work on an elaborate one to demonstrate how it is done. A stamp, a pad, and paper, can make a uniquely personal gift.

⟪$⟫ Print from your initial stamp using a purchased stamp pad or ink-soaked paper towel in a saucer. Try also stamping a blob of sealing wax or candle wax. Work fast; a warm surface under the paper will help retard cooling.

Select from these three basic block-letter styles to carve a single-initial eraser stamp. All the letters shown here are constructed with straight lines to make carving simple.

[$] *Add decoration to a monogram with simple, geometric, repeated shapes.*

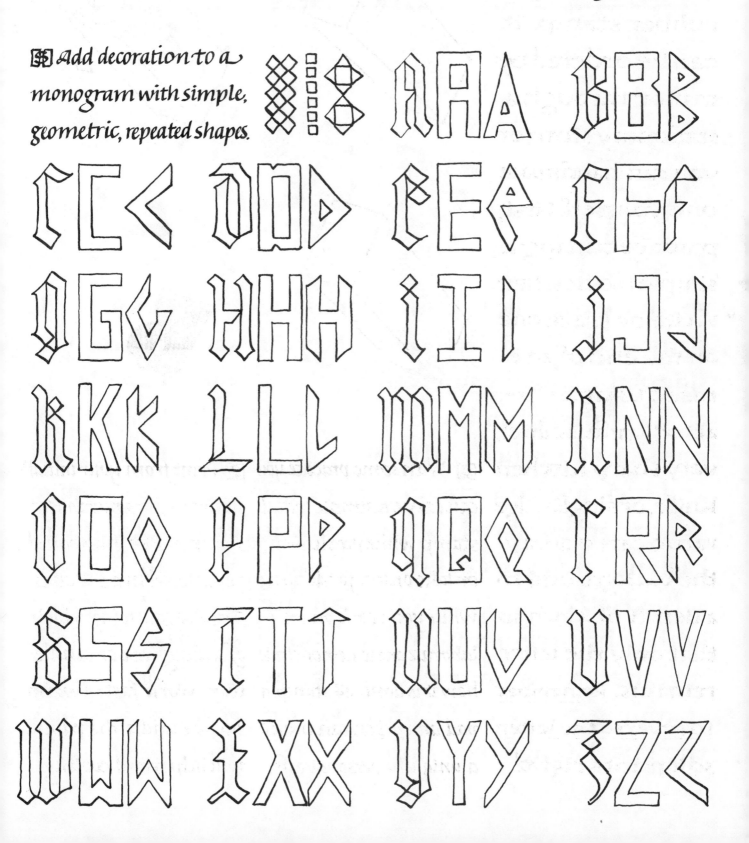

1.

2.

3.

4.

5.

6.

For more complicated monogram designs, slice a ⅛ inch layer off the largest side of the eraser, using a large, sharp cleaver or butcher knife. Then coat one side of the slice with library paste, and stick it onto a scrap of paper. Draw design right way round. Cut away all the background area. Coat the remaining carved letters and the eraser surface with rubber cement, let dry, & bond together. Moisten back of paper by stamping gently on a damp sponge, then peel design off stamp.

Once you master the technique of cutting a stamp you can begin to explore the art of printing with it. Try small interlocking repetitive elements, geometric backgrounds, simple ornaments, & symbolic emblems. Experiment as well with a variety of stamps, pads, inks, and paper surfaces.

[$] If your design is too complicated or lengthy to carve with either of the techniques shown here, check your Yellow Pages to find a manufacturer of rubber stamps. Some stationery stores may be able to get a catalog for you to order your rubber stamp custom-made for a moderate charge.

[$] Since custom-made rubber stamps involve an intermediate step, many manufacturers charge less for a second stamp made from the same design. Consider offering a standardized border, ornament, or texture to fit a number of your custom-designed initials and monograms.

[$] Make and use eraser stamps in your own calligraphic work to give an intriguing texture to unconventional designs. Stamps can help you to visualize repeated units in a border, or encourage you to experiment with abstract designs that use one letter over and over.

You can transform a loose stack of 50 rubber-stamped monogrammed stationery sheets into a nifty pad of notepaper. Start with half-sheets for convenience the first time you try. Knock about 50 sheets flat on one edge. Keep in place with clothes pins, bulldog clips, or c-clamps on a ruler. Swab generously with rubber cement. Let dry. Coat a 1"x 5½" strip of paper. Let dry. Bond firmly together & rub off excess glue.

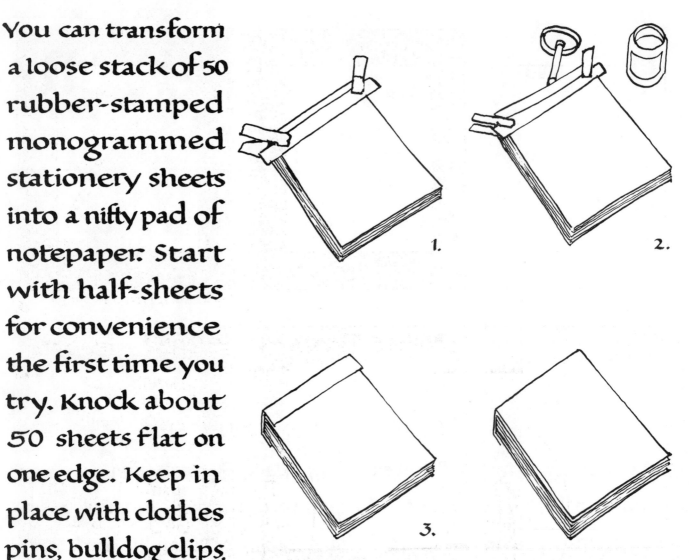

1.

2.

3.

[$] To make your pad of notepaper more appealing add a decorative cover of colored or patterned paper. Make it 1" longer than the notepaper so it reaches around the pad. Decorate with title & name.

[$] Another attractive addition to personalized notepaper is a sheet of guidelines to slip under each page. Make it 1" longer than the pad and attach it to the bottom of the back cover cardboard.

1.

2.

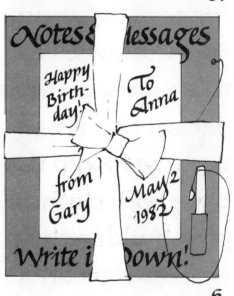

Braid cord to prevent twisting

3.

4.

Notes & Messages

Write it Down!

5.

Notes & Messages

Happy Birth-day! To Anna from Gary May 2 1982

Write it Down!

6.

Back your notepads with stiff material for extra durability and decorativeness. Use chipboard, mat board, cardboard, or two layers of oaktag.

[$] *To make a raised letterhead, cut an initial or symbol from matboard with a sharp knife. Then tamp paper over it with your fingers to "blind-emboss" it.*

[$] *The ultimate note-pad includes an extra-wide margin of stiff backing for a reinforced hanging hole, a pen string and holder, and a hand-lettered ornamental title message.*

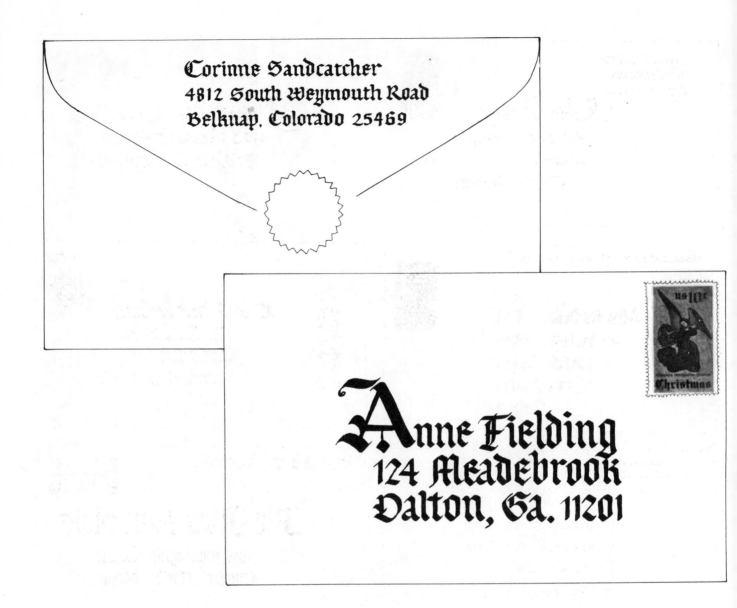

The obvious thing to do with notepaper is to write to someone on it, put it into an envelope, address it, seal it, stamp it, and send it. Attention to calligraphic detail will not only make each of these ingredients more appealing by itself but also contribute to a sustained, unified overall design. You can learn to select color, spacing, and alphabet to suit the style of each letter you send.

Edward Gable
Hatch House
Bog. Or. 92122

Robin Dale
140 Story Street
Newton
Massachusetts

MEYER, 240 MAIN, CORHAM. TEXAS 62102

Miss FREDERIKA DAY
45 WALNUT LANE
CARSONVILLE
VIRGINIA
71559

Sylvia Warner
401 B Avenue, N.W.
Easton, Utah 42001

Bella Winters
414 Jefferson Place
Talbottville
New Mexico 41414

Mr. and Mrs. James Kelly
4123 Pleasant Street
Brighton, Oregon 92122

29 West Street
Ely, B.Q. 60426

Robert Graham
201 Garden St.
New London
Connecticut 20801

May, 29 W. 79th N.Y.C. 10005

Mr. & Mrs. Paul Blair
7016 Huntington Avenue
Carson, Florida 80029

The fundamental thing that sets the style is the tone of your message — elegant, amorous, or reassuring, calligraphy can echo it.

¶ When you plan the appearance of envelopes for a mailing ask your post office for a selection of commemoratives, & gear your color scheme to what will be available.

To avoid disappointment, always buy the stamps BEFORE you address the envelopes. It is a small detail, but it makes the difference between weak and strong visual impact.

Envelope addressing can be simplified a great deal by making a template for the guidelines in one of two following ways. If your envelopes are made of a single thickness of lightweight, light colored paper, cut a file card to ¼" less than the envelope size and rule your guidelines onto that with ink. Then slip it into each envelope so that the guidelines show faintly through.

For a beginner, addressing envelopes can be like getting paid to practice, if you take intelligent precautions to head off potential problems. Be sure the price & design are firm, insist upon a typed list, and have extra envelopes for mistakes.

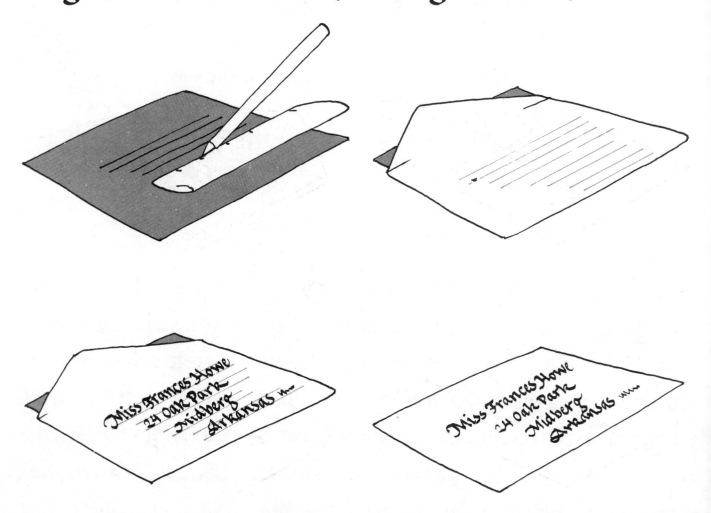

§ *If someone asks you to address envelopes in a color that's only to be found in a water-based ink, don't despair. Be sure ink is dry and pencil marks are all erased. Then spray each envelope lightly with a clear fixative spray so it will not smear or run.*

If your envelopes are made of a dark, heavyweight paper or have opaque or patterned lining, you will need a template that helps you to rule pencil guidelines directly onto the envelopes. Using a sharp blade, trim one narrow sliver of paper out of a file card for each guideline. If your lines have to be very long, leave a small reinforcing bridge of paper across the middle.

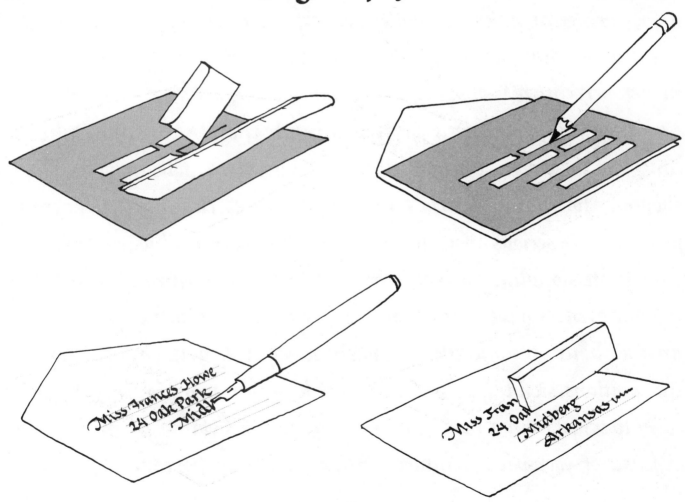

Many beginning calligraphers find it difficult to know what to charge. It helps if you first analyze what category of work the job belongs in, and then evaluate it on that basis.

You may find yourself selling things that can be more or less "mass-produced" beforehand and sold in quantity. They may have a significant materials cost. You should price things like this by the ITEM — some certain amount for each one, with perhaps a discount for the purchase of a number of them. If, however, you intend to sell items through commercial stores, you must allow for their mark-up. For a $10 item sold to a customer, an art store or stationery store will pay you $5, a bookstore $6. For a $10 consignment item, a gallery or craft store will pay you around $7, but since the store has no particular incentive to sell these items, your higher percentage is offset by slow turnover.

Another way of pricing a job is to estimate the TIME it will take to complete the work. Include all the time involved: talking to the client, shopping for special materials, making mistakes, cleaning up. If at some point you are serious about turning your hobby into a business, price your time professionally. Pay yourself four times the minimum hourly wage in your area. For every hour you spend with pen in hand, you will spend another hour on non-lettering, business-related chores, a third hour on the vacations, sick leave, and coffee breaks any reasonable employee has come to expect from a boss, and a fourth hour providing for the overhead expenses of workspace, furniture, utilities, and transportation.

Some kinds of jobs demand a mixture of pricing. For instance, you may find it makes sense to estimate an envelope-addressing job in terms of how much time it will take, and then give your client a price per item. If someone asks you to spend extra time selecting special materials or dealing with the printer, add a reasonable amount onto your bill to reflect the value of the time you put in. You may also need to offer a price range for lettering a poem or favorite quotation—a certain amount to start with, based on the number of lines, plus as much more as the client wishes to spend to make the piece more elaborate.

You begin by making, pricing and selling things; you progress to selling your time; ultimately you arrive at the level where you sell your EXPERTISE. Don't underprice it. You are selling not only the hour it took to design the monogram but also the day you spent thinking about it and the decade you spent learning your skill. And since expertise sometimes consists of knowing what to leave out, a simple design does not necessarily have to cost less than a complicated one, or take less time.

One further element in pricing to bear in mind is that there is in every job an implied sale of RIGHTS. The right to own and enjoy a piece of calligraphy is not the same as the right to reproduce it. Prevent misunderstandings by spelling out very explicitly just what it is that the client is purchasing from you. One-of-a-kind art is not to be reproduced without the artist's permission. Art commissioned for reproduction is for one-time use on a specific project; a client who wants to use it for another purpose should consult you. And if the artwork is to be reproduced and sold for profit,

you should receive a small percentage of the retail price as a royalty for your contribution to the project's ongoing success.

Four additional minor guidelines may help you price your calligraphy appropriately. First, too low can be worse than too high. Human nature being what it is, if your work is below par people forget what a bargain it was and just remember that it wasn't done right; if the quality is high, people remember the price and don't respect the work. And in the long run you just make it harder for yourself and your fellow calligraphers to make a living. Second, if you do any work for free, make sure the recipient knows its true value and spell out clearly what kind of publicity, services, or free copies you expect in return. Good will is almost always better if it is specific. Third, avoid tying up much of your own money buying specialized materials or paying the printer. Ask for an advance to cover any out-of-pocket expenses you will have.

Fourth, virtually every problem in pricing becomes easier as you gain experience. Ralph Waldo Emerson says, "There is no courage like the courage of having done the thing before," and there certainly is no confidence like the confidence you have in knowing that you are charging what your calligraphy is worth. If you are just starting out, ask other calligraphers how they price their work — what the "going price" is for such standard jobs as designing an invitation, lettering a quotation, engrossing a diploma, addressing an envelope. If there are no other calligraphers around, ask other freelancers in related fields how they would charge for a roughly equivalent piece of work. DON'T BE SHY!

Calligraphy
Projects

CHAPTER
III

Calligraphy in your Library

CALLIGRAPHY in your LIBRARY

For nearly 2000 years of recorded history, calligraphy's natural habitat has been the pages of a bound book. For the last 450 years, however, printing rather than hand lettering has filled most volumes. Today, calligraphy is easing its way back into use for writing in books.

The beginning calligrapher starts by putting handlettered additions in printed books and progresses to making a whole book from scratch. Either way, the scribe must learn not only to write but to see. Choose the books you like best & really study how they are put together. Pay attention to the letter or type style, letter weight, letter spacing, line spacing, margins, page proportions, page order, paper color & texture, cover paper, and binding technique.

Browsing in libraries or bookstores will educate your eye as well as your brain. And it's free!

Learn from books not just by reading but also by looking. You can store up answers to design questions that will arise as you integrate your own calligraphy into printed books or create a complete volume. Many visual decisions are up to you—the individual letters are just a beginning.

Once you have studied calligraphy and page layout you may never again feel the same about desecrating a book by underlining, highlighting, writing in the margins, or turning down the corner of a page. And yet you will need to write in a book occasionally. It can be done in a way that adds to the book if you plan carefully, to prevent errors and harmonize with the book's style.

If you feel you just have to mark passages so that you can find them again, try making your own index instead. Turning to a blank page at the end of the book, note your page number and a one-word cue or phrase. Write small.

§ An individually personalized index elevates a gift book to a treasure. An index, along with a table of contents, adds an extra dimension to any scrapbook or photograph album.

§ To index a book that isn't yours, work on a separate card. Be sure to identify the book with complete bibliographical detail: title, author, year of publication, publisher's name and address.

The simplest inscription puts the owner's name inside the front cover. More elaborate ones may be centered, ornamented, and illuminated, and can include owner's address, date, donor's name, occasional details, a quotation, and greetings of a formal or friendly nature.

Of course the most straightforward way to personalize a book is to write a name on one of the front pages. The inside front cover is the most permanent & therefore most thief-proof; a fly leaf is most conspicuous, especially if the inside front cover is partly obscured by the flap of a dust jacket; the title or half-title pages are traditionally associated with authors' inscriptions; the back page with owners' warnings.

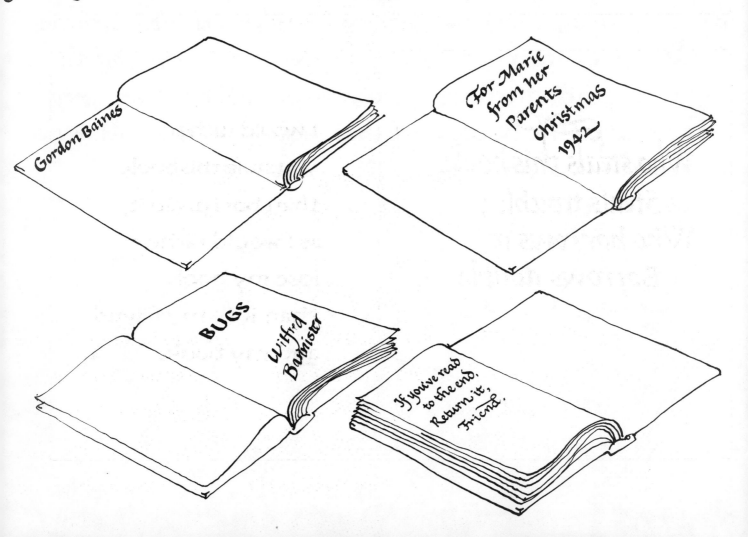

With Appreciation

for guidance and support
this book is presented to
John C. Barge
by
The Old Train Club

June 10, 1980 Chattanooga

GIFT OF
Karen Grass

Who steals this book
Steals trouble;
Who borrows it
Borrows double.

I would rather
you stole this book
than borrowed it,
as I would rather
lose my book
than lose my friend
<u>and</u> my book.

If you make your book-ownership inscriptions fancy enough, and have enough of them to do, it is time for a bookplate. They can be purchased ready-made from bookstores or mail-order sources and filled in with the owner's name. Or you can do an original design. Have it reproduced on gummed paper or adhesive-backed material. You can also use plain paper with a thin layer of white library paste spread evenly over the back.

[$] Are you at a loss for literary inspiration? Use a collection of familiar quotations; check under the headings of READING, WRITING, BOOKS, LETTERS and related topics for book plate quotations.

[$] Don't make the bookplate too large. 3" × 5" is more than enough; reduce to smaller sizes to give a sharper, clearer, cleaner effect that looks right with the typography of most books.

from the record collection of

Ex Libris

People say that
life is the thing
But I prefer reading.

Logan Pearsall Smith

EX
LIBRIS

My Book & Heart

shall never part.

AldousHuxley · Chrome yellow
THE PROER
STUDY OF
MANKIND
IS BOOKS

From the
collection of

ABC
DEF
GHIJ
KLM
NOP
QRS
TUW
XYZ

Books,
the
children
of the
brain

Jonathan
Swift

SOME
BOOKS
LEAVE
US
FREE
AND
SOME
BOOKS
MAKE
US
FREE

Ralph
Waldo
Emerson

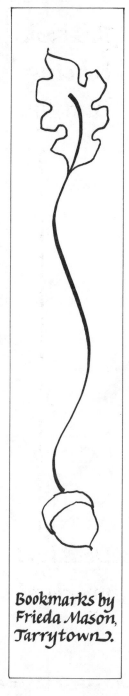

Bookmarks by
Frieda Mason,
Tarrytown.

You
cannot
open
a book
without
learning
some-
thing

CONFUCIUS

🔖 Intelligent choice of ink, paper, color, wording, and style can help carry out a historic theme. Save your paper scraps & decorative oddments.

Bookmarks are useful, versatile, & cheap to make. They take a minimum of time & yet their elongated proportions challenge your design skill. To be useful, they should be at least six times as tall as their width and made of thin, stiff

A home without books is like a house without windows ◇

This book is being read by:

Don't lose my place!

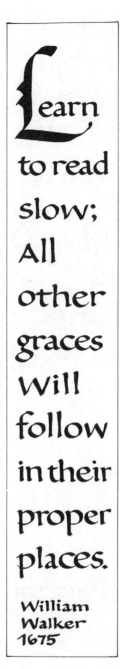

BOOKMARK

Learn to read slow; All other graces will follow in their proper places.

William Walker 1675

BOOKMARK

material. Glue two layers together if the paper is too limp. Tie a tasselled soft cord through a hole in one end if you want a more glamorous effect. A bookmark can be made simple enough to give away or elaborate enough to sell.

※ Letter people's names onto bookmark strips for gifts and irresistible giveaways at craft fairs. Include your name on the back of promotional items.

You can evoke the custom bindings of past centuries, and protect a favorite or much worn book cover, by folding a decorative fitted dust jacket around it. This cover can be as detailed or as simple as the book seems to call for.

§ Elaborately detailed artwork can be printed for a fundraiser book-cover project and then personalized with titles, names, or monograms.

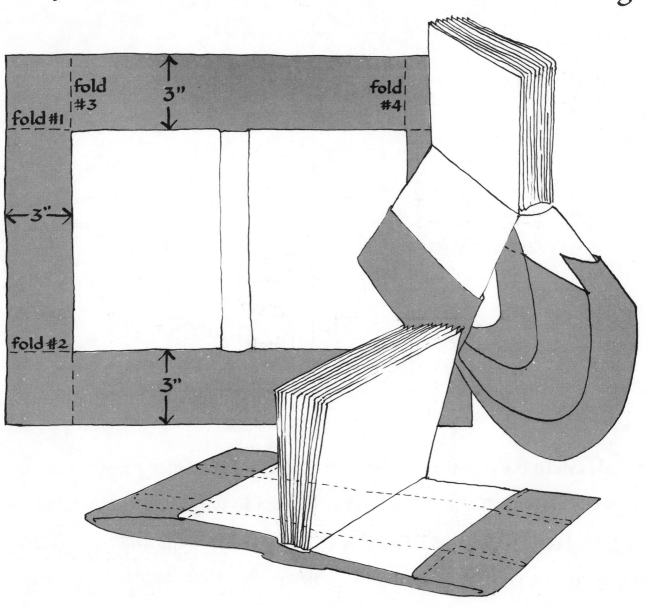

fold #1

fold #3

3"

fold #4

3"

fold #2

3"

[$] Re-covered second-hand books can be recycled as gifts or money-makers. Suit the letter style to the book's subject matter.

[$] For a truly memorable set of book accessories, design a bookplate, bookmark, and book jacket around a single motif—a quotation, emblem, or monogram.

[$] Protect your handmade book covers with transparent adhesive material or several layers of transparent waterproof spray.

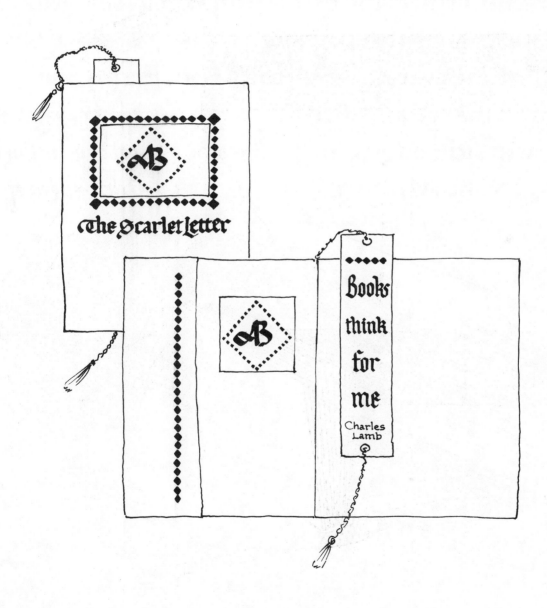

Make your own book by collating, folding, and stitching 8~12 sheets plus a heavier cover. Sew with needle and heavy thread. Standard 8½" x 14" 'legal size' paper folds down to a convenient and pleasing 7" x 8½". Estimate your margins by beginning with about $\frac{1}{20}$ of the page height as the unit of measure. Use 2½ units for the center margins, 3 for the top, 4 for the outside edges, and 5 for the bottom as shown here.

Smaller, more utilitarian books can be made without stiffer covers— using 'self-covers'—and stapled along the back —keeping the points of the staple inside the book. Fold 8½" x 11" sheets into quarters, staple, and slit bottoms of pages. Use a pencil or your finger for a deckle-edged effect.

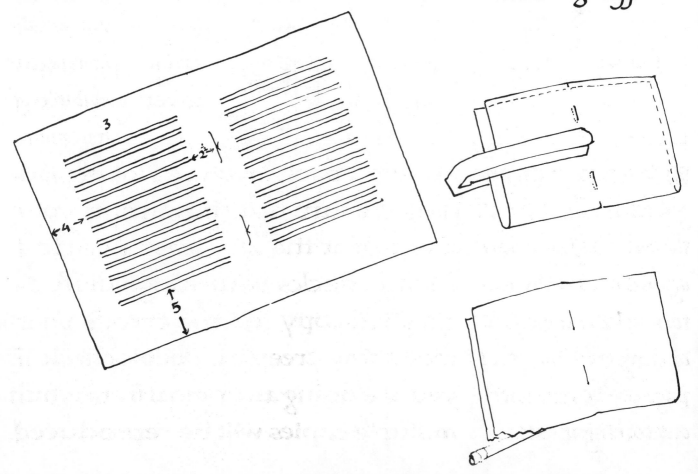

⌘ Plan your book in "spreads" to visualize what the open book will look like each time you turn a page. A typical 16 page book is shown here.

cover		

copy-right	preface
4	5

dedi-cation	page 1
6	7

page 6	page 7
12	13

page 8	page 9
14	15

inside cover	half-title
	1

page 2	page 3
8	9

colo-phon	inside cover
16	

blank	title
2	3

page 4	page 5
10	11

back cover

you can add more pages in multiples of four only.

⌘ Save time with one guideline sheet for all the book's pages. Guard against catastrophic errors by lettering before binding so an incorrect page can be redone without tearing it out.

Making a book involves a lot of planning. Be sure that the author, your client, or at the very least a critical friend checks your rough draft & finished copy for the errors that inevitably creep in. Double check if you are doing an original from which multiple copies will be reproduced.

Finally, your library—whether it is an oak-panelled study or a bricks & boards bookshelf—should have an atmosphere that encourages reading. Promote it with silent reminders to set the tone. Don't be apologetic about your list of rules; inscriptions reveal that even the ancient Greeks had them. After all if we

expect the best from our books we should be willing to return the compliment.

Not Smoking

Quiet

THE FLUE IS OPEN

THE FLUE IS CLOSED

When you invent a useful design that does not use a copyrighted text, you can copyright it. But be sure the text is in public domain; trying to copyright someone else's text can lead to trouble!

That book is good which puts me in a working mood.

emerson

You READ for your own pleasure, for your solace and strengthening. Pleasure, then, purely selfish? Solace which endures for an hour and strengthening for no combat? Ay, but I know, I know. With what heart should I live here in my cottage, waiting for life's end, were it not for these hours of seeming idle reading?

GEORGE GISSING

It's what you read when you don't have to, that determines what you'll be when you can't help it.

Reverend D.F. Potter

PUT BACK THE BOOK

No girl was ever ruined by a book.

New York Mayor Jimmy Walker

82

A TYPICAL INVOICE — Use purchased carbon forms or improvise your own.

• BILLHEAD — rubber stamped, typed, imprinted, or TODAY'S DATE.
handlettered, with your name as you want it to
appear on the check, and your mailing address. sequential identifying #.

CLIENT name,
address, &
telephone #.

Lydia Bellinghouse	May 12, 1982
LETTER BUG	Invoice #82512
2481 Borgland Street	your P.O. #481021
Murrain, Mo. 42211	

Client's PURCHASE

ORDER #.

SOLD TO:	SHIPPED TO:
Clarified Enterprizes, Inc	Clarified Subsidiary
40 Clarified Highway	80 Second Street
Murrain, Mo. 42213	Murrain, Mo. 42212
404-227-4801	

SHIPPING ADDRESS if

different from billing.

NAME of
person you
dealt with.

| Ordered by Frank Clary | Net 30 days | One-time use only |

206	Name tags lettered	$2	$ 412.00
	25 % rush fee (under 5 days)	50¢	103.00
240	Name tags purchased for job	$4 doz	80.00
	15 % materials handling charge		12.00
1 hour	Consultation	$15	15.00
	Postage		8.00
	TOTAL		$630.00

TERMS of SALE.

TERMS of PAYMENT.

QUANTITY.

DESCRIPTION
of work or goods.

EXTENSION
(Quantity x unit price.)

Any special EXTRA exact POSTAGE or UNIT RUSH CHARGE.
MATERIALS. TIME. a handling charge. Price.

TOTAL.

TWO COPIES for the client;
ONE COPY for your records. Check your state & local tax regulations.

Finishing a piece of calligraphy — whether it is a one-line bookmark dashed off in a hurry or a fifty-line epic concluded as the sun comes up — always gives the scribe a special glow of satisfaction. But there are still a few steps remaining to turn this work of art into a job well done.

First, cool off for a few hours. Then **PROOFREAD** the work to check it for errors (or ask a friend to check it). If a mistake does slip through and the recipient catches it, apologize but at the same time explain that calligraphers do occasionally make mistakes. Then fix the error at no charge to the recipient, or do the piece over.

Second, **SIGN AND DATE** your work whenever you can without interfering with the design; at the least, sign and date it in pencil on the back. If you expect to add to it or do more lettering that must match it, add some details about pen size, line spacing, and ink color.

Third, provide an attractive **PROTECTIVE WRAPPING**.

Fourth, write up a simple but business-like **BILL** that includes all the information shown here. The more specific the better.

Fifth, keep a **COPY** of the piece of calligraphy.

Sixth, **DELIVER** the work or have it picked up.

Seventh, if you haven't been **PAID** by the agreed-upon time, telephone to check whether there is a problem with the bill.

Eighth, add the client's name to your **MAILING LIST** and put the copy of the job into your portfolio. Now on to the next job.

I
lettered
this book out in a
humanist Bookhand for
the text and a narrow Italic for the
commentary, using two custom-designed
Koh-J-Noor pens, 1.25 mm and 1.00 mm respectively.

COLOPHON

Headings and some illustrations were lettered with
Mitchell Roundhand pens. Illustrations
were outlined with a Rapidograph
.00 pen and lettered with
Roundhand, Scroll
and Art-
pens

.

To the guest in my library
who shows symptoms of
wanting to borrow this book from me

Steal
it outright!
don't politely ask
if I would care to lend,
For I'd rather lose my book
than lose my book
and my friend